GW00374130

A CONCERT OF

A · N · G · E · L · S

WITH HEAVENLY CHOIR MUSIC

Copyright © 2005 by edel CLASSICS GmbH, Hamburg/Germany
Photo copyright see photo credits
Music copyright see music credits

All rights reserved.
No part of the publication may be reproduced in any manner
whatsoever without permission in writing from the publisher.

ISBN 3-937406-58-1

Editorial Direction: Astrid Fischer/edel
Art Direction and Design: Anna Bertermann
Adapted for earBOOKS mini by Petra Horn
Photo Editorial: Tanja Ohde, www.in-multimedias-res.de, Cologne/Germany
Music compilation: Bernd Kussin/edel

Produced by optimal media production GmbH, Röbel/Germany
Printed and manufactured in Germany

earBOOKS is a division of edel CLASSICS GmbH
For more information about earBOOKS please browse **www.earbooks.net**

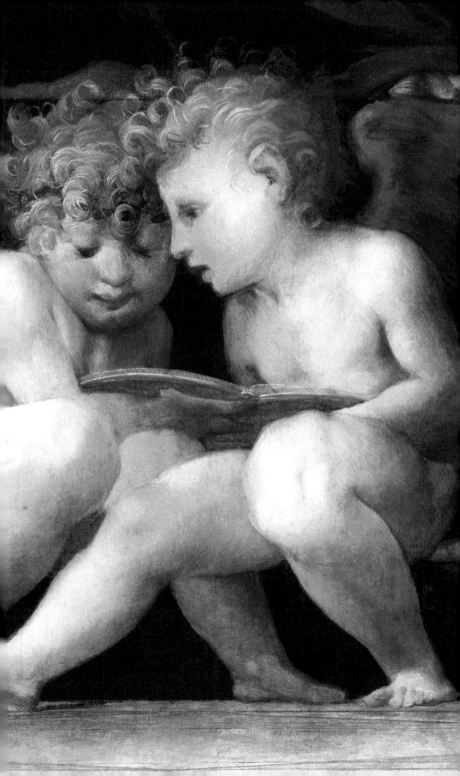

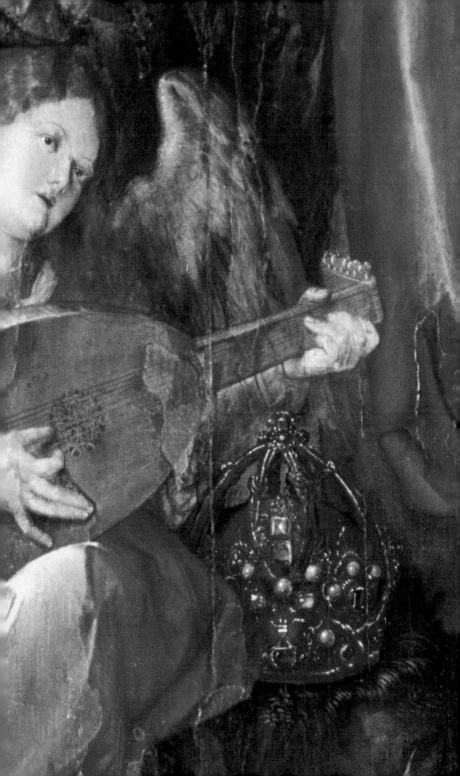

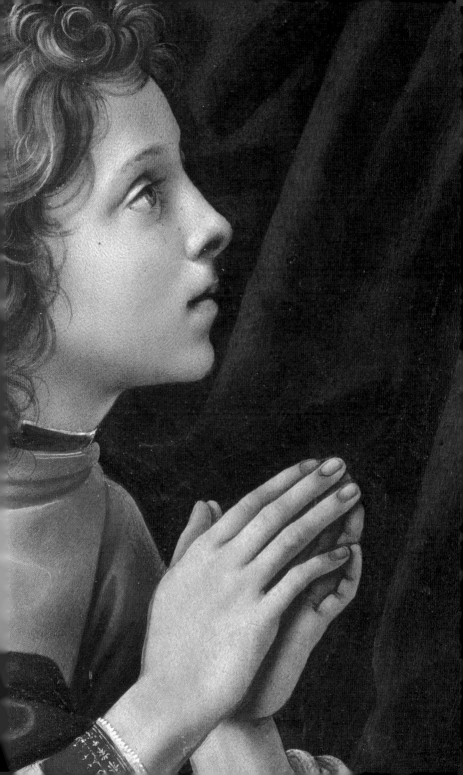

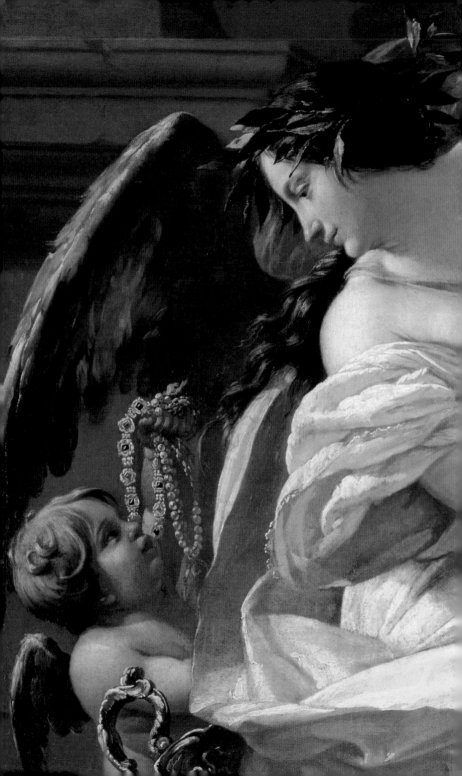

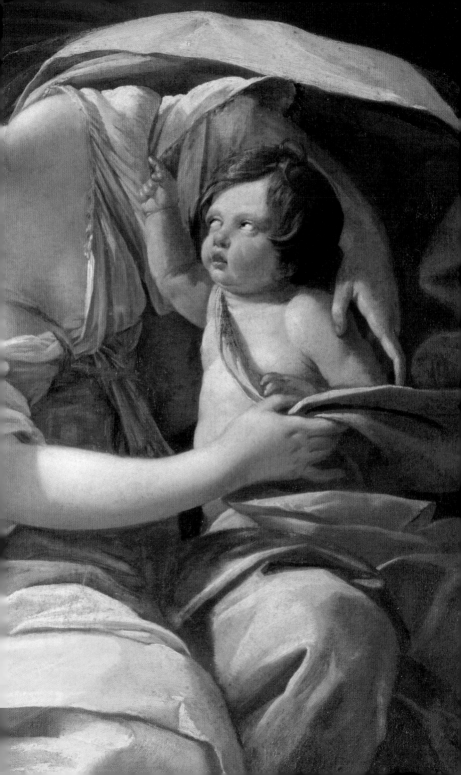

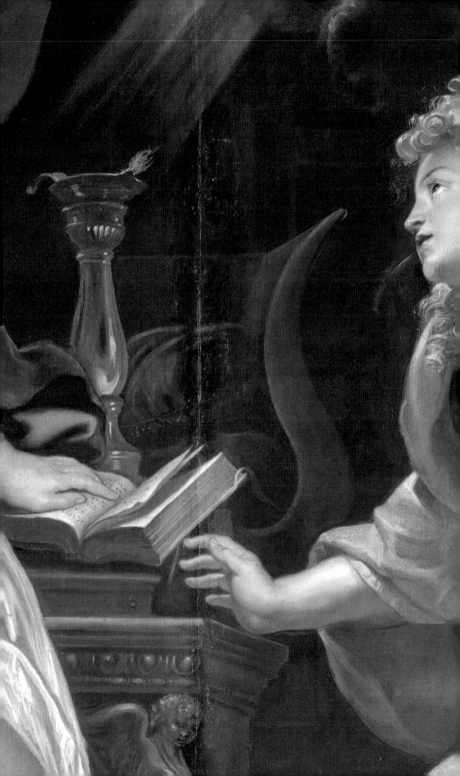

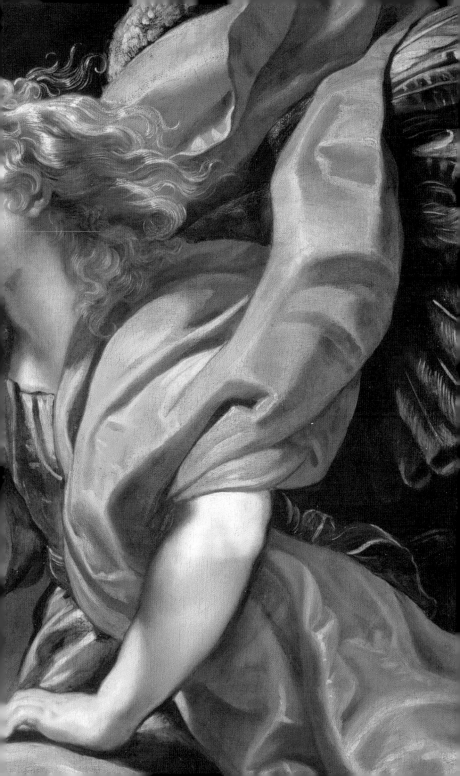

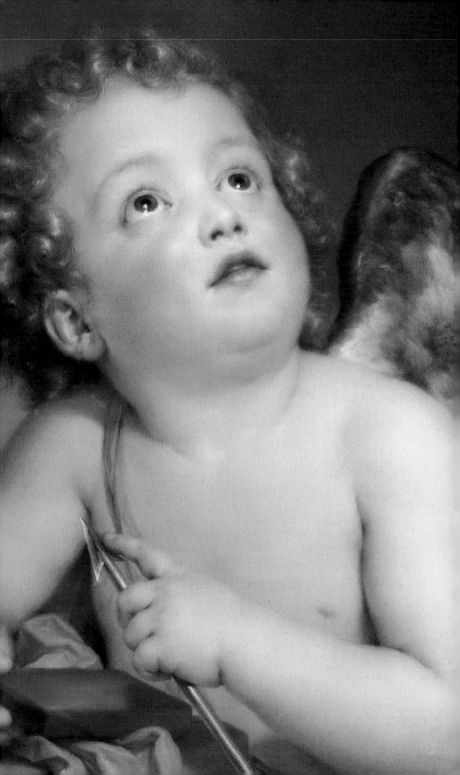

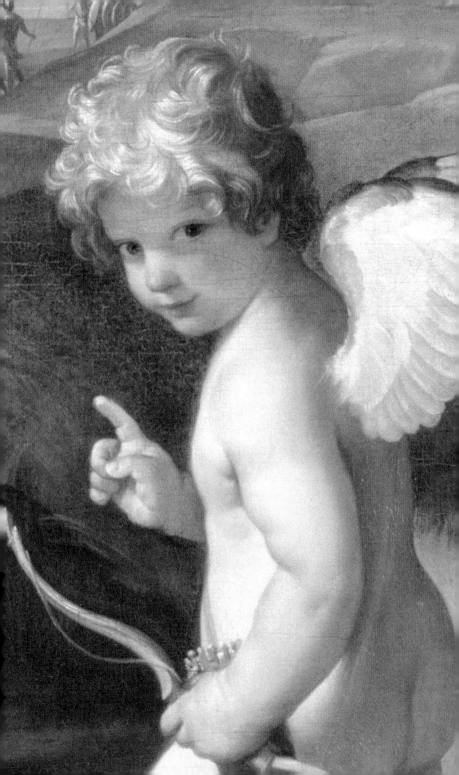

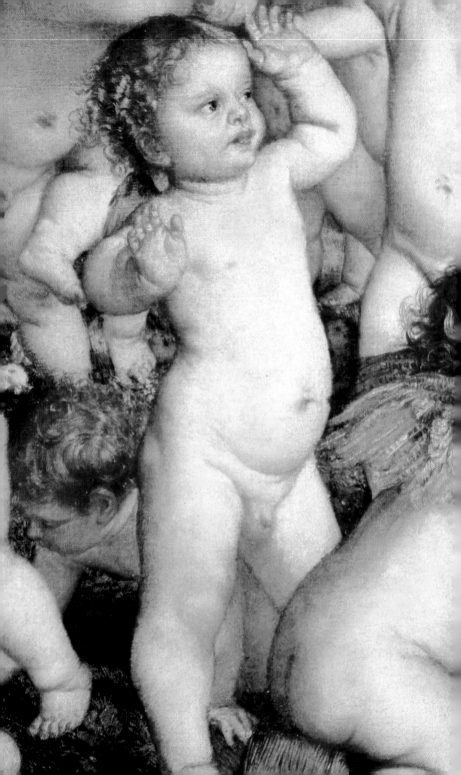

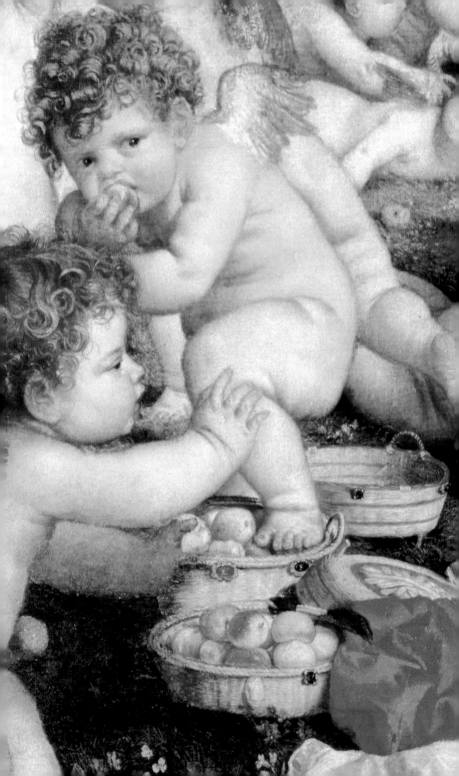

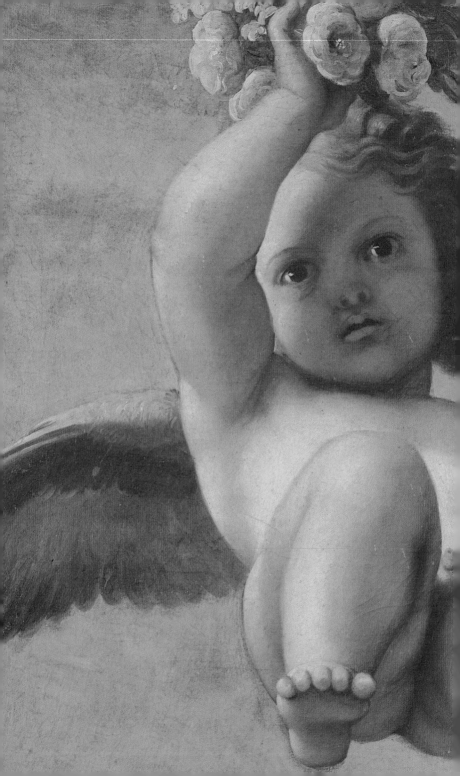

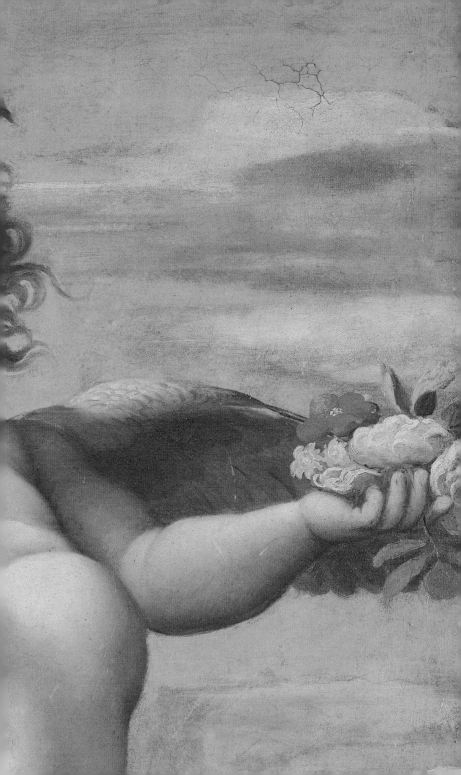

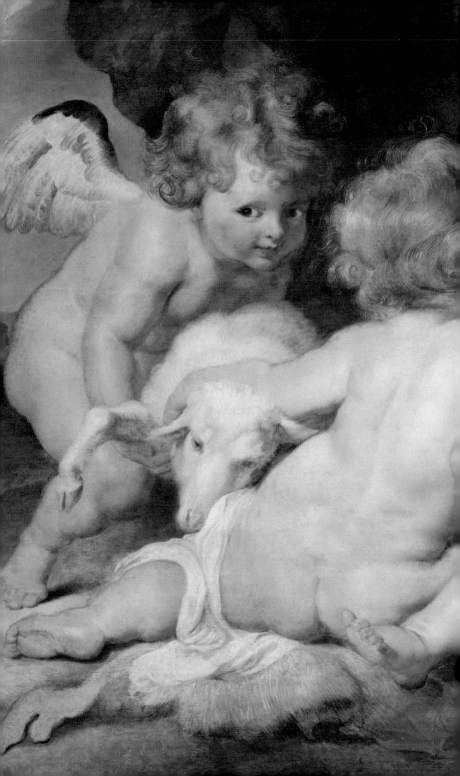

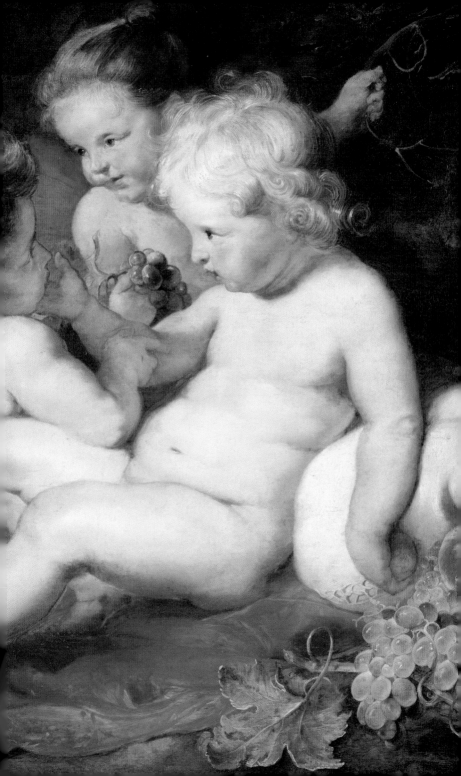

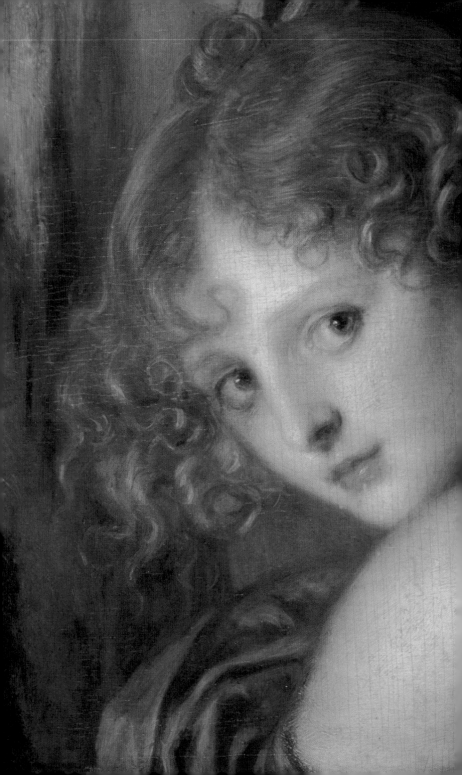

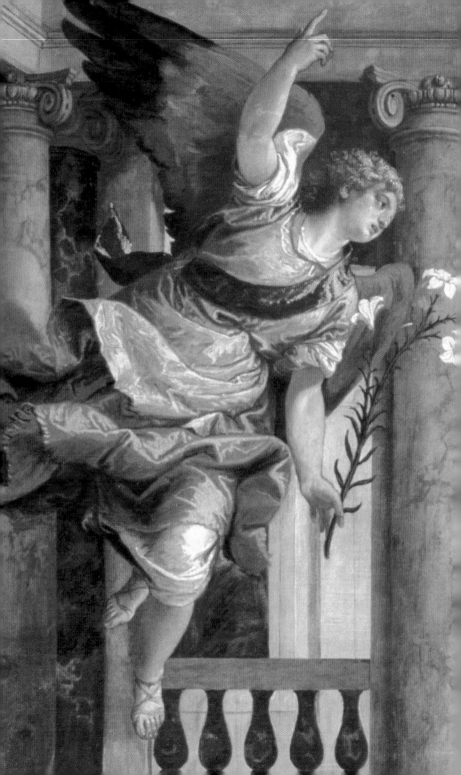

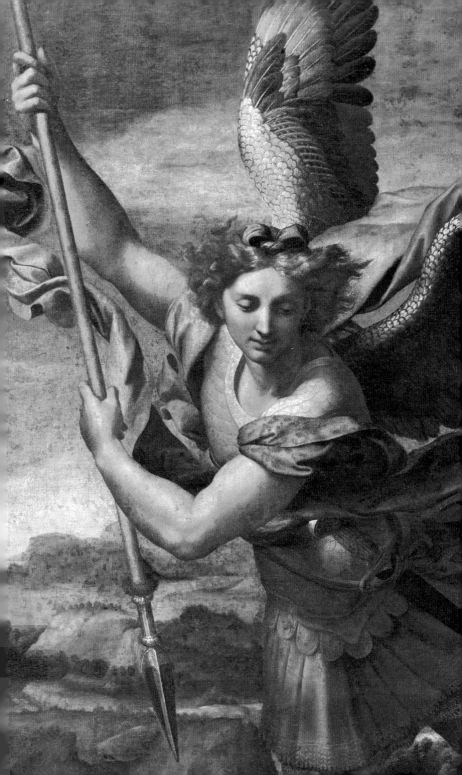

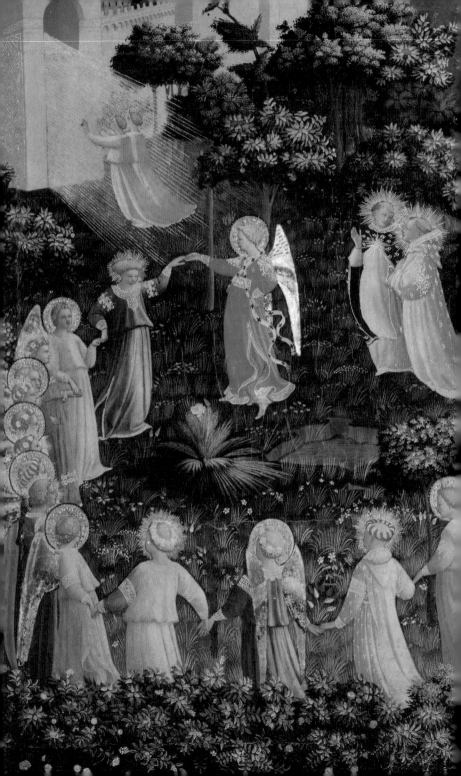

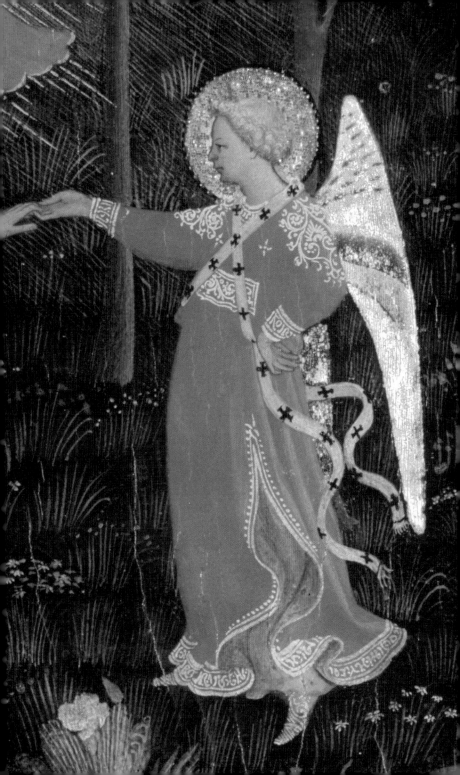

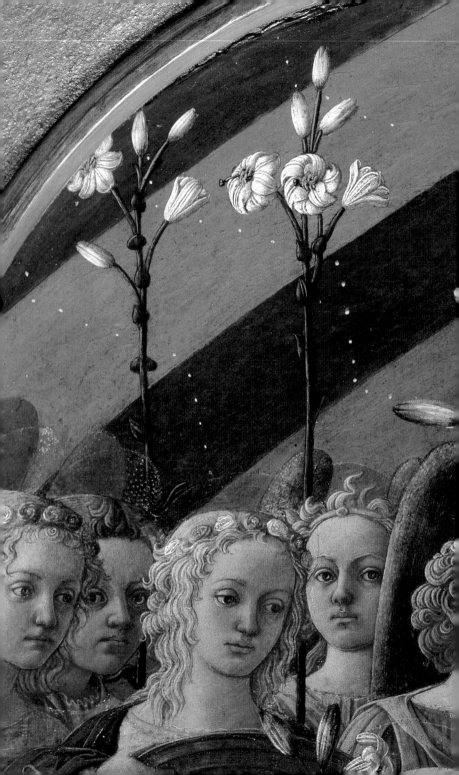

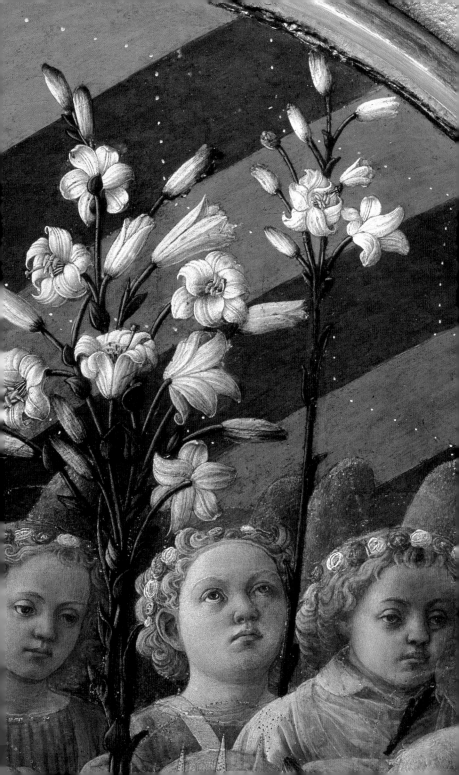

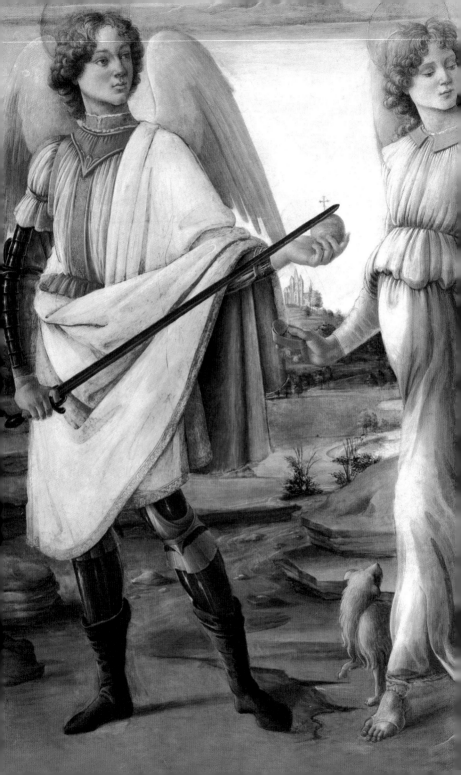

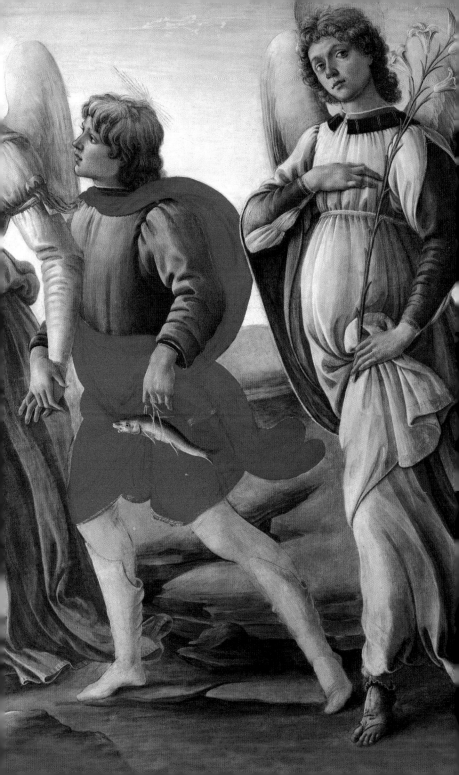

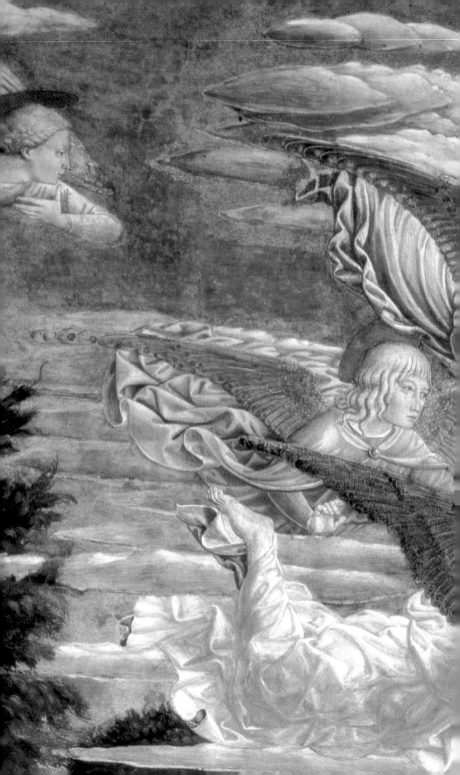

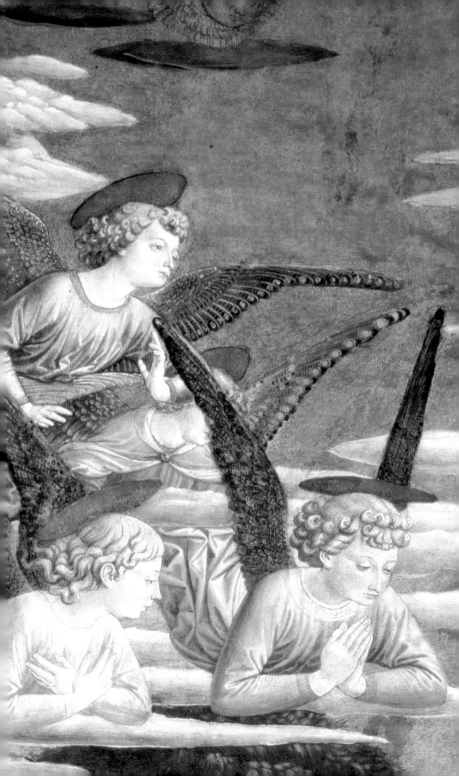

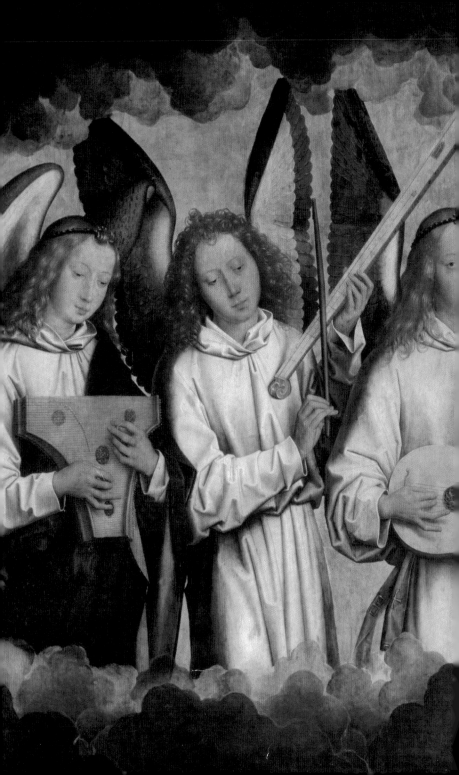

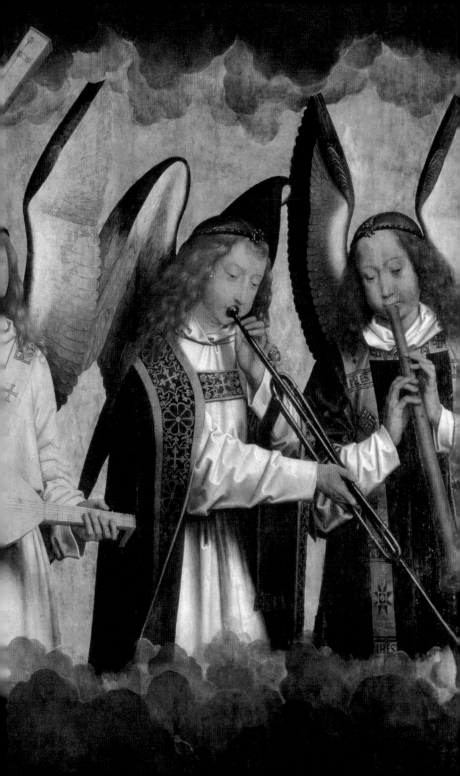

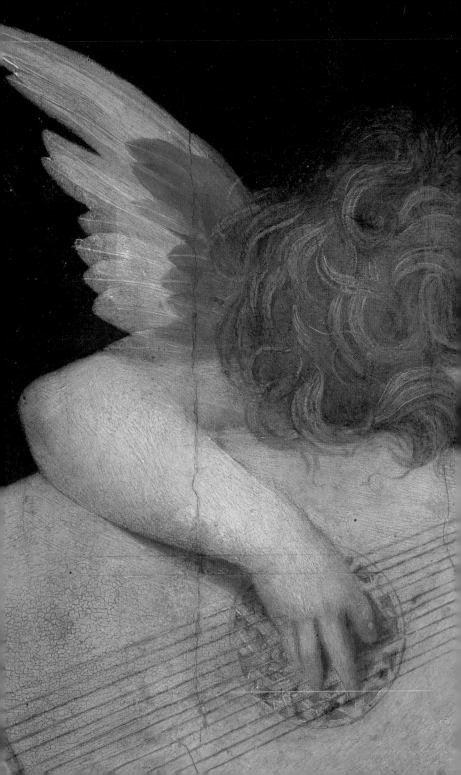

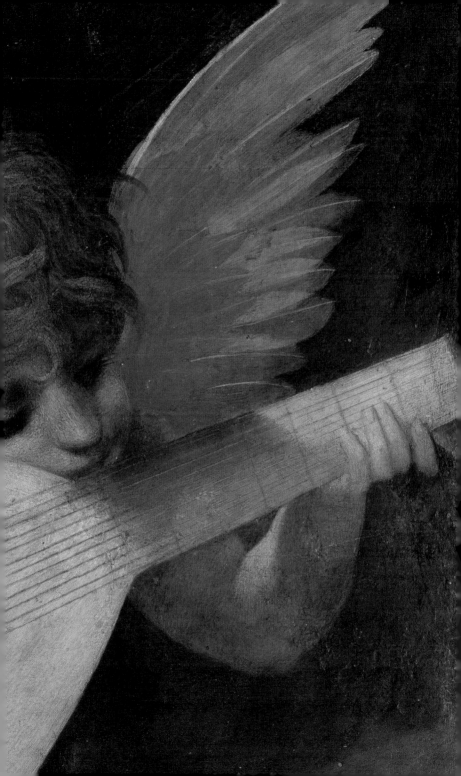

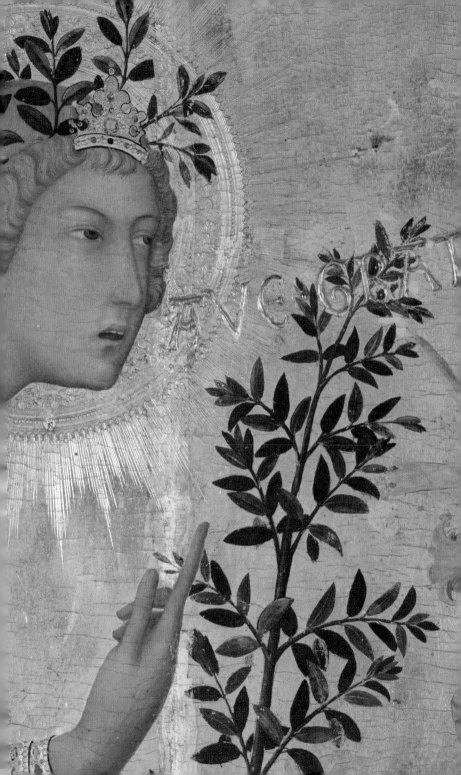

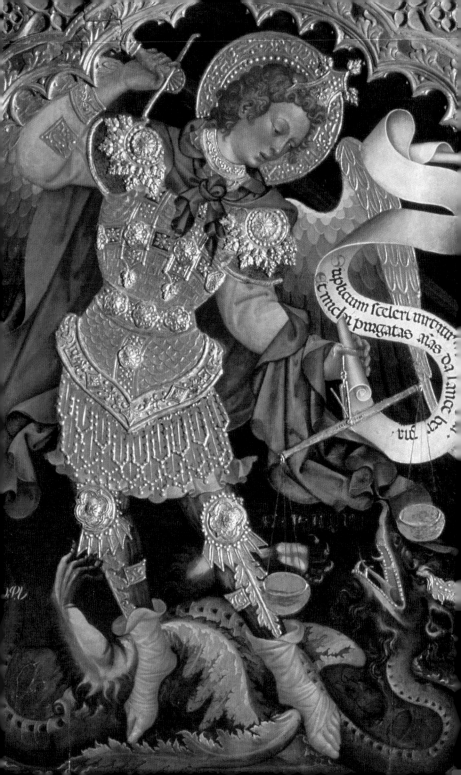

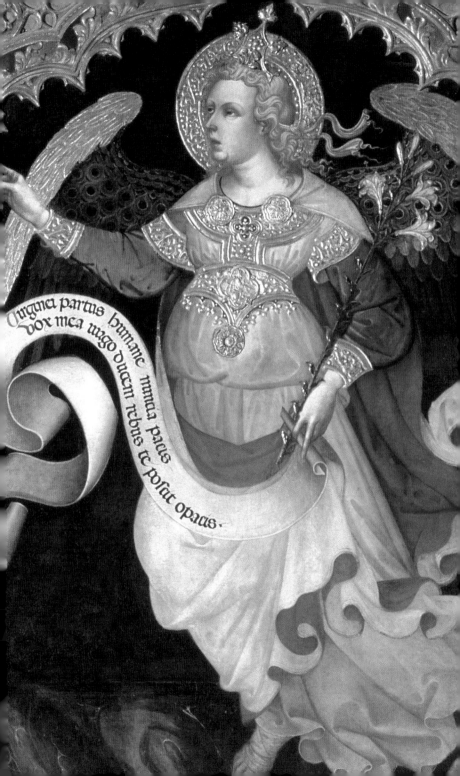

SECVND IESV
VM·MAT CHR
LIBER IST I·
GENERA FILII·D·
TIONIS AVID

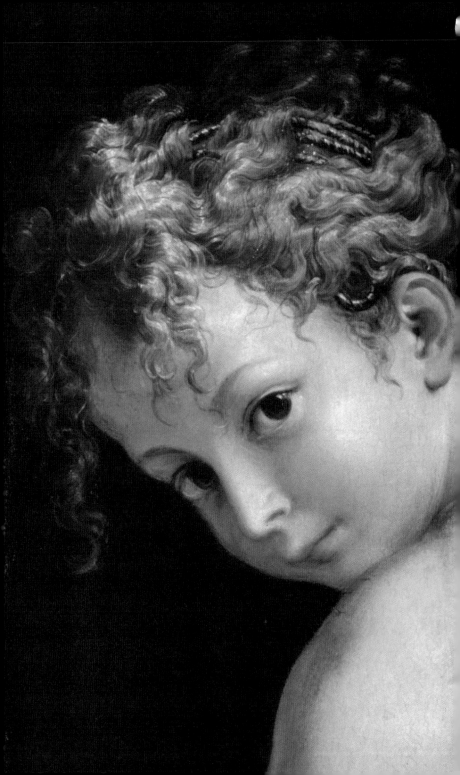

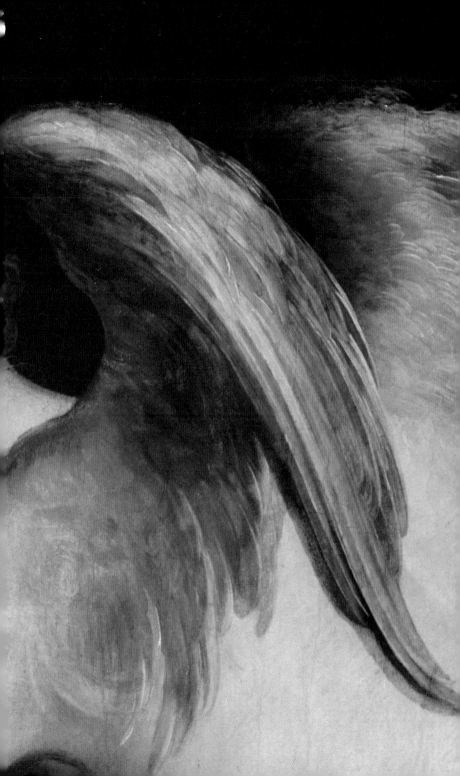

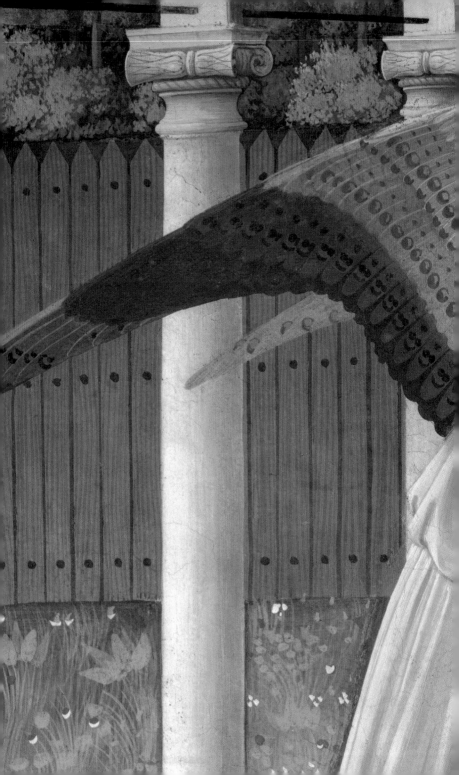

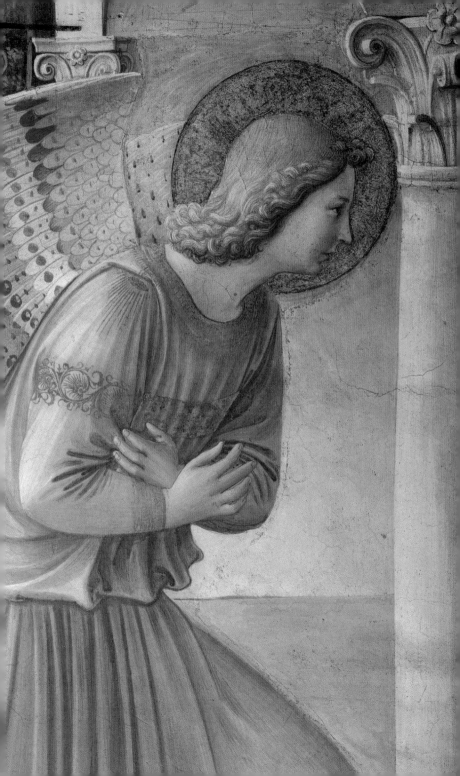

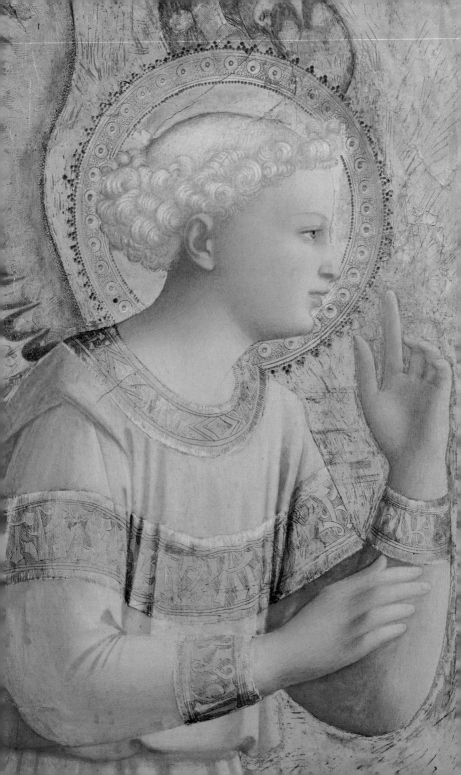

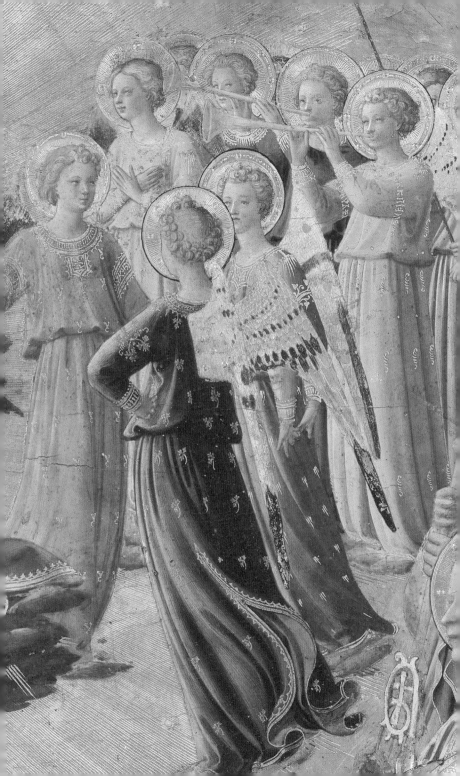

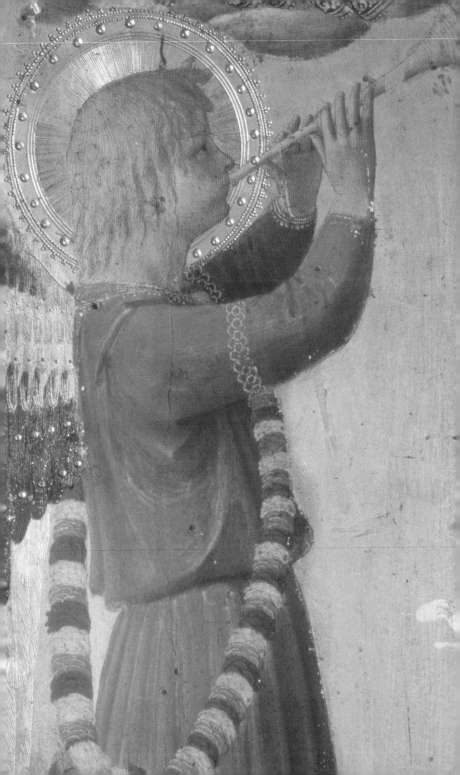

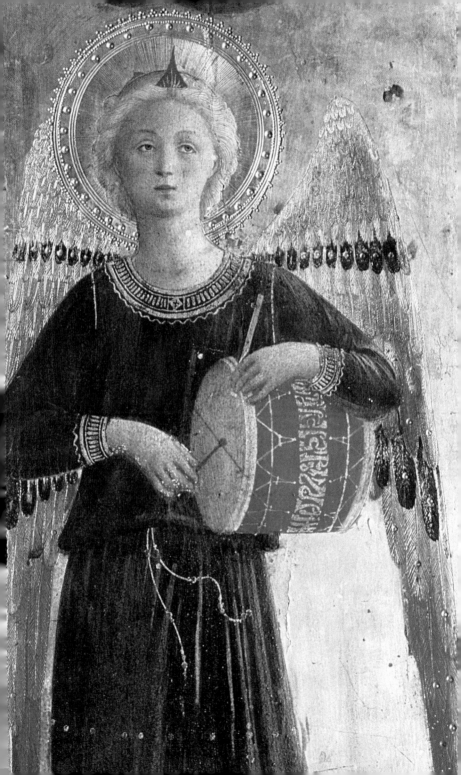

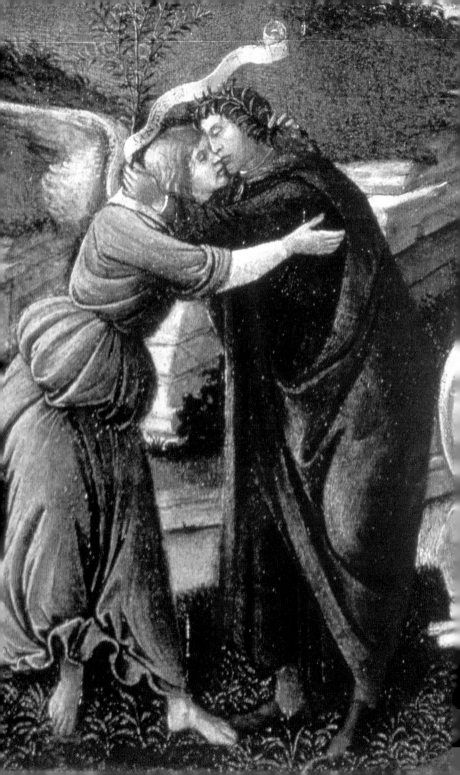

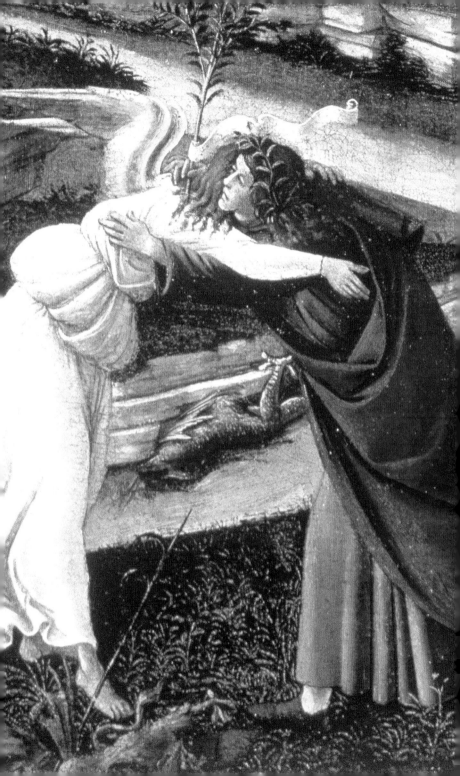

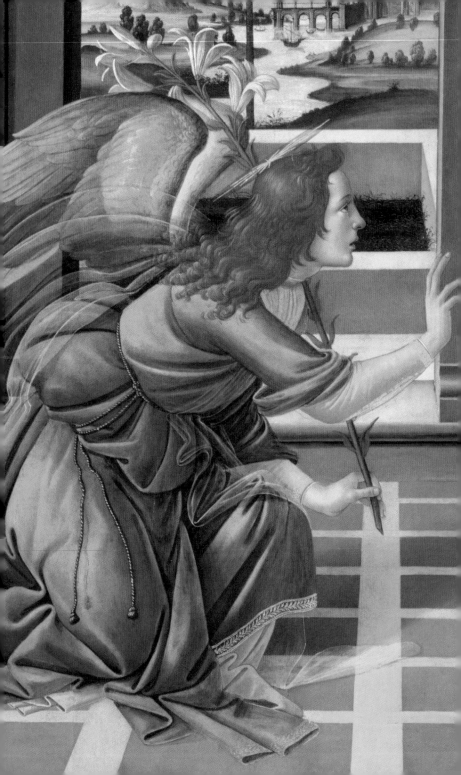

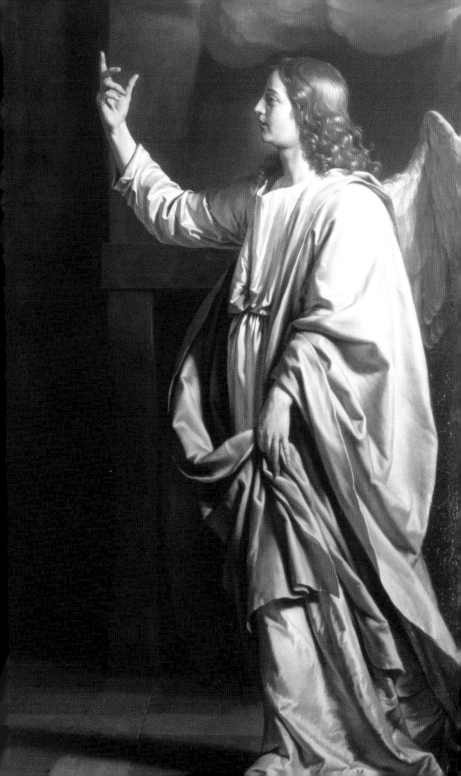

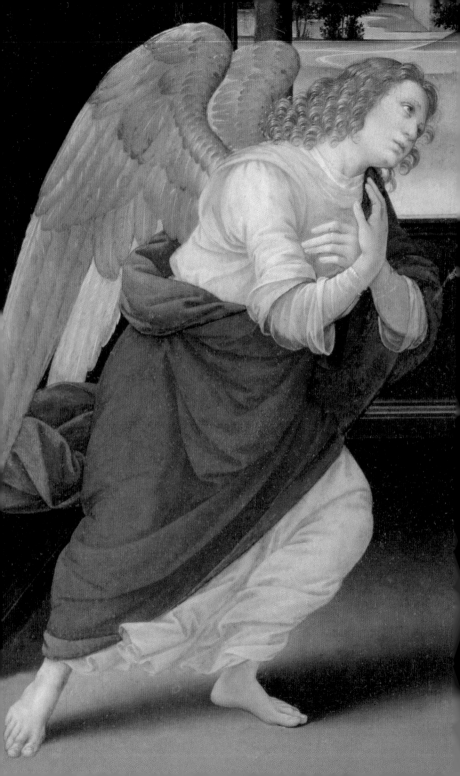

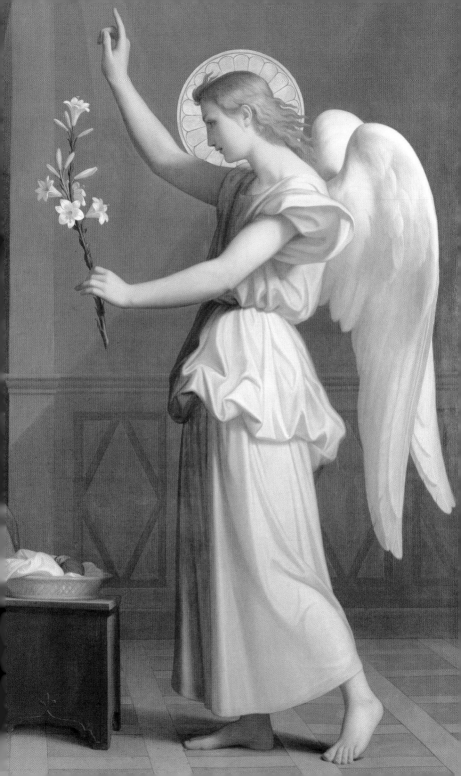

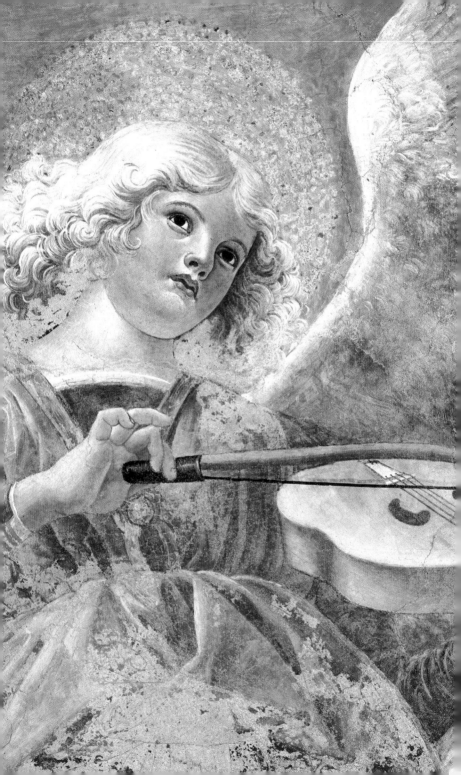

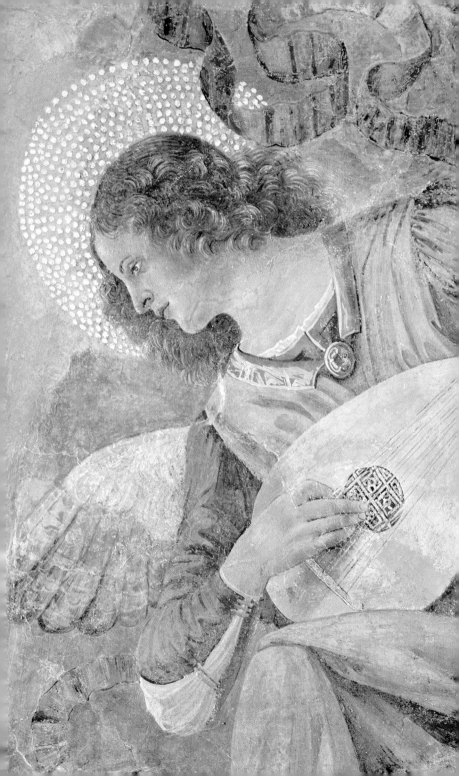

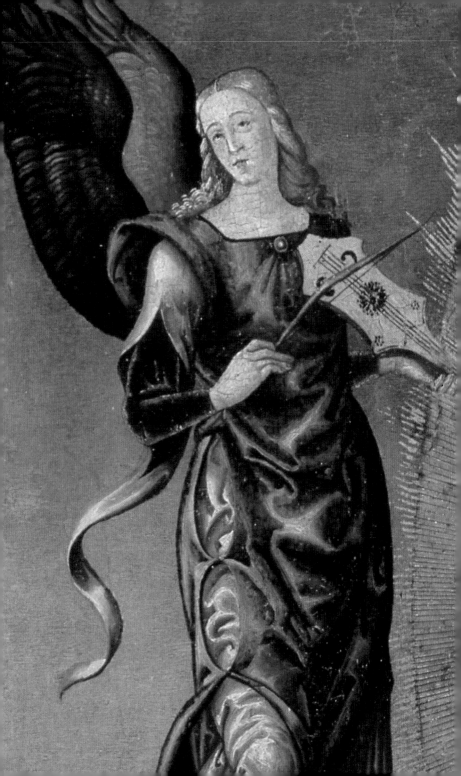

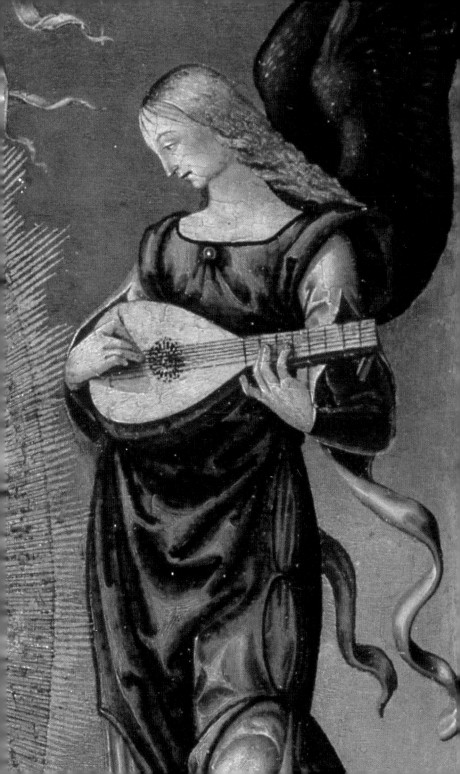

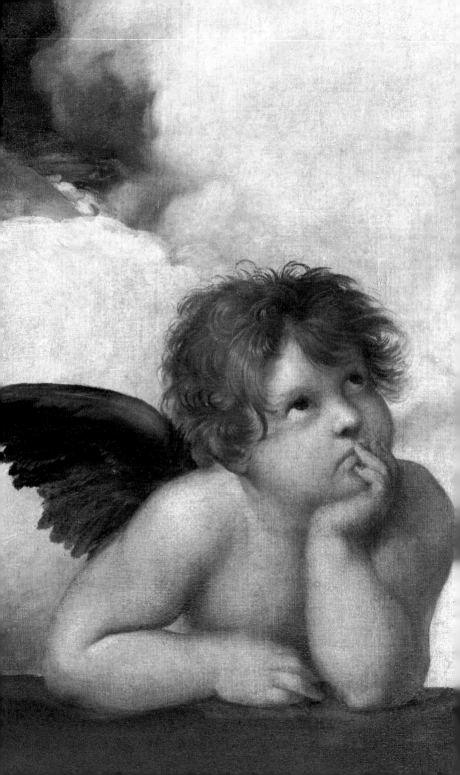

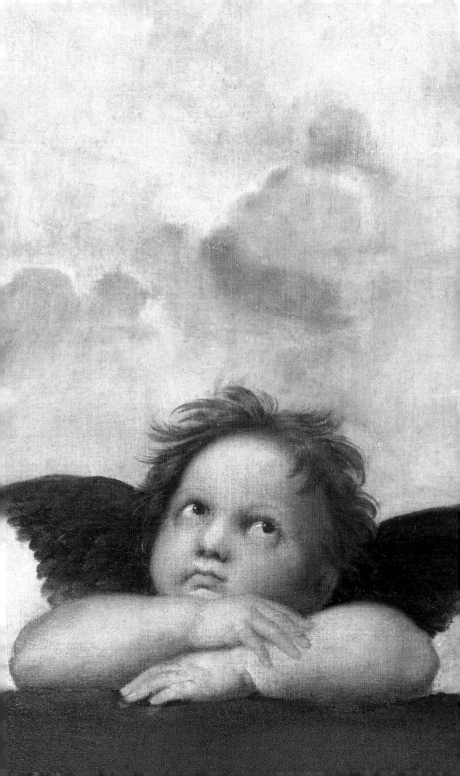

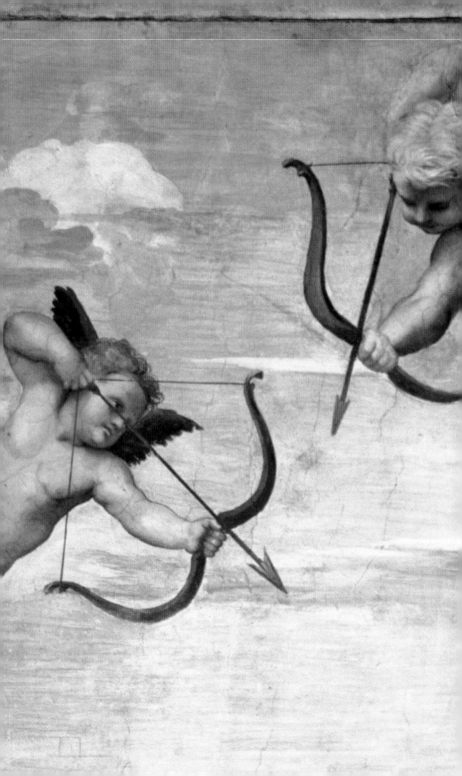

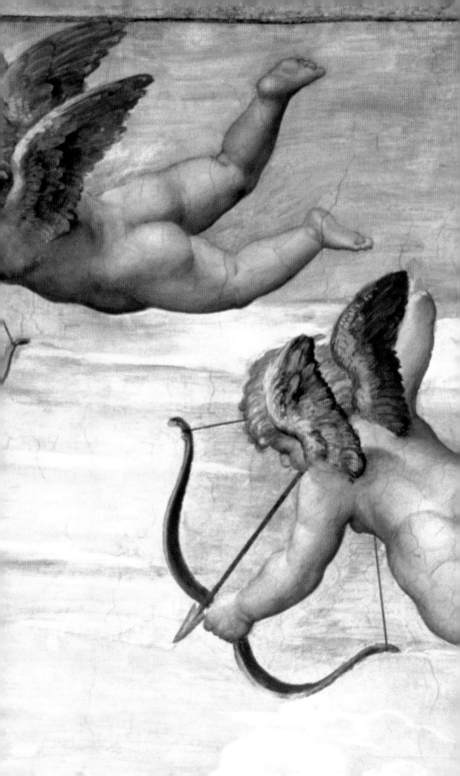

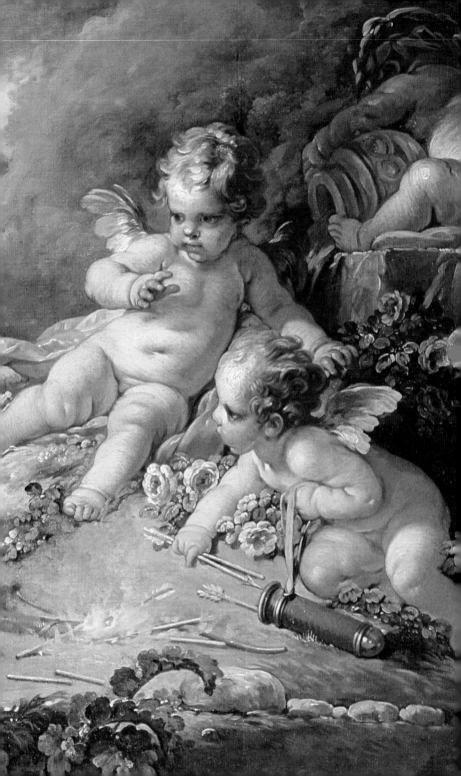

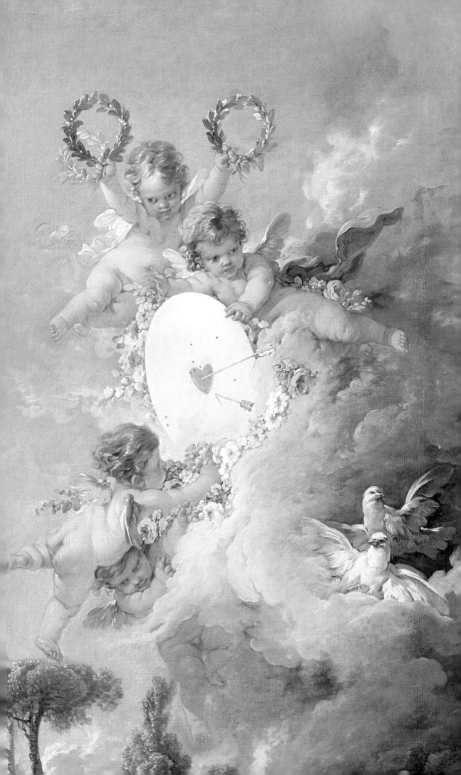

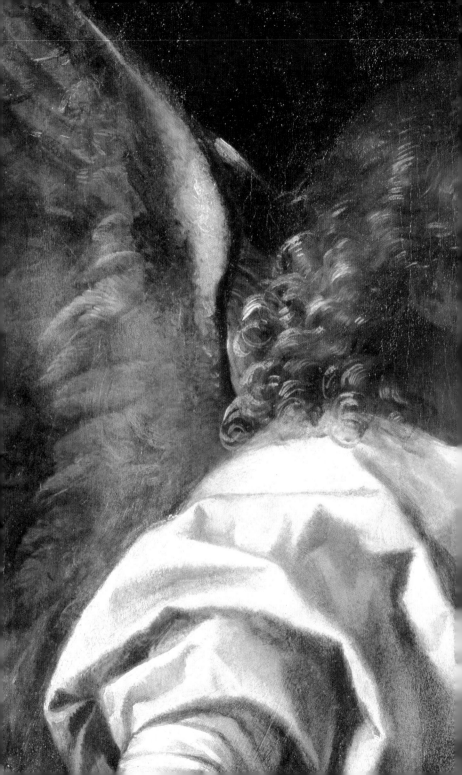

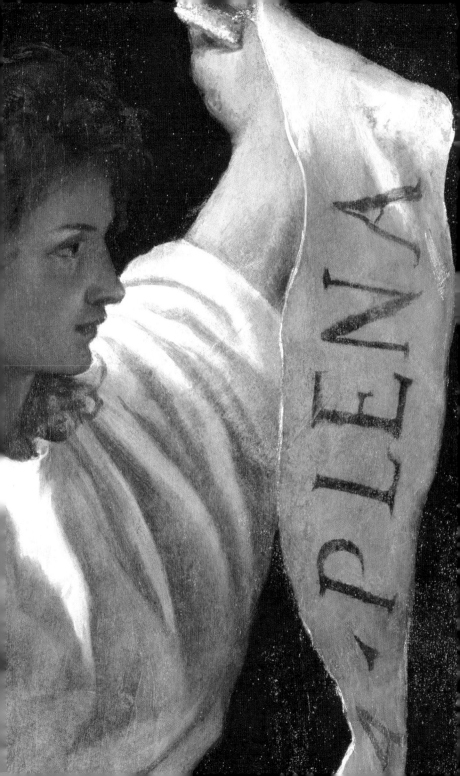

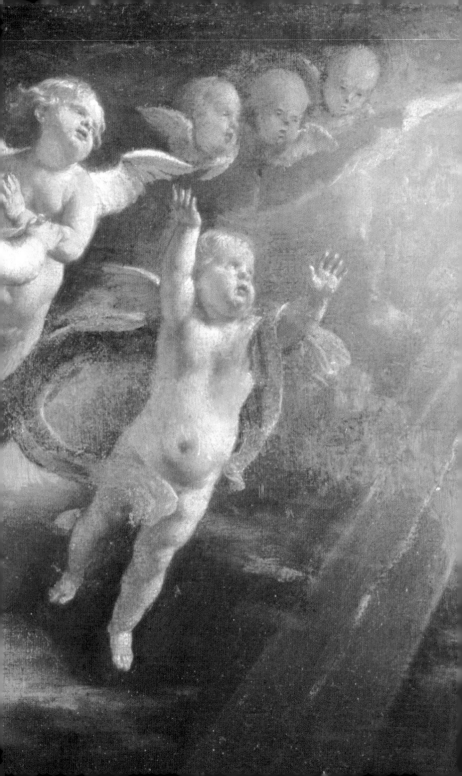

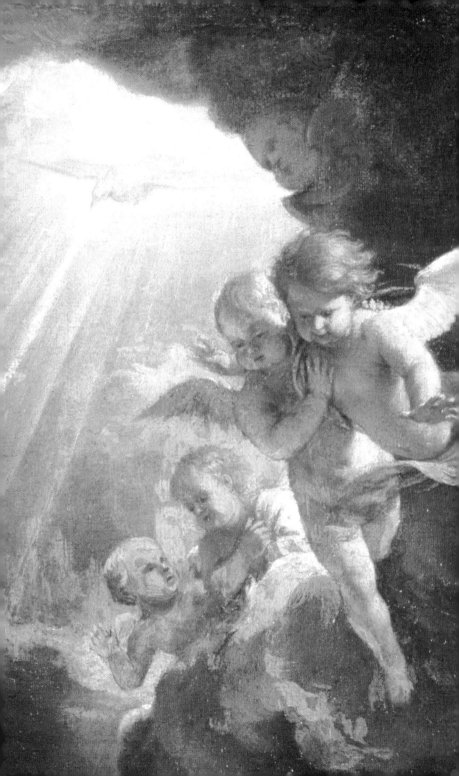

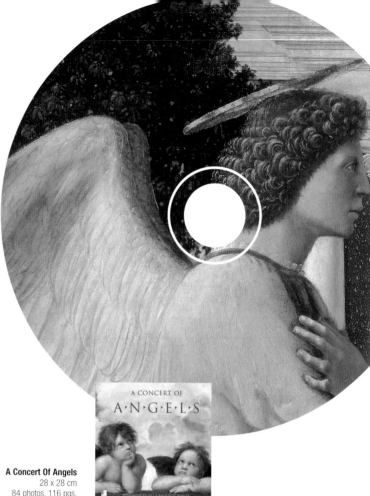

A Concert Of Angels
28 x 28 cm
84 photos, 116 pgs.
4 Music CDs
ISBN 3-937406-36-0

Gefällt Ihnen dieses Buch?
Noch mehr Bilder und Musik genießen Sie
im earBOOKS Großformat.

If you liked this book,
you will enjoy the large format earBOOKS
with additional music and pictures.

Si vous avez aimez ce livre, vous l'apprécierez
dans sa version earBOOKS grand format,
avec encore plus de musiques et de photographies.

CD

GEORGE FRIDERIC HANDEL (1685-1759)
Der Messias (Messiah)
[1] *Halleluja! (Hallelujah chorus)* _4:06
 Großer Rundfunkchor Berlin
 Rundfunk-Sinfonie-Orchester Berlin
 Helmut Koch
 ℗ 1971*

HEINRICH SCHÜTZ (1585-1672)
Psalmen Davids (Psalms)
[2] *Jauchzet dem Herrn* 100. Psalm
 („Make a joyful noise unto the Lord"), SWV 36 _5:38
 Dresdner Kreuzchor
 Rudolf Mauersberger
 ℗ 1967*

JOHANN SEBASTIAN BACH (1685-1750)
Mass in B minor BWV 232
[3] *Osanna in excelsis* _3:02
 Rundfunkchor Leipzig
 Neues Bachisches Collegium Musicum
 Peter Schreier
 ℗ 1984*

JOSEPH HAYDN (1732-1809)
Die Schöpfung (The Creation)
[4] *Und Gott sprach -*
 In vollem Glanze steiget -
 Die Himmel erzählen die Ehre Gottes
 (And God spoke -
 in splendour bright now rises -
 the heavens are telling of the glory of God) _7:45
 Peter Schreier, tenor
 Regina Wernes, soprano
 Theo Adam, bass
 Rundfunk-Solistenvereinigung Berlin
 Rundfunkchor Berlin
 Rundfunk-Sinfonie-Orchester Berlin
 Helmut Koch
 ℗ 1976*

WOLFGANG AMADEUS MOZART (1756-1791)
Vesperae solennes de confessore K.339
[5] *Laudate Dominum* _5:01
 Edith Mathis, soprano
 Dresdner Kapellknaben
 Staatskapelle Dresden
 Bernhard Klee
 ℗ 1979*

JOHANNES BRAHMS (1833-1897)
Ein Deutsches Requiem (A German Requiem) op.45
[6] *4. Wie lieblich sind deine Wohnungen*
 (How lovely are thy tabernacles) _5:50
 Rundfunk-Solistenvereinigung und
 Rundfunkchor Berlin
 Rundfunk-Sinfonie-Orchester Berlin
 Helmut Koch
 ℗ 1973*

JACOBUS GALLUS (1550-1591)
[7] *Zwei der Seraphim (two of the seraphim)* _2:57
 Dresdner Kreuzchor
 Rudolf Mauersberger
 ℗ 1971*

HEINRICH SCHÜTZ (1585-1672)
Psalmen Davids (Psalms)
[8] *Singet dem Herrn ein neues Lied*
 (sing a new song to the Lord) _6:46
 Dresdner Kreuzchor
 Rudolf Mauersberger
 ℗ 1967*

MAX REGER (1873-1916)
[9] *Nachtlied (Night song)* _2:47
 Dresdner Kreuzchor
 Gothart Stier
 ℗ 1992**

FELIX MENDELSSOHN BARTHOLDY (1809-1847)
[10] *Denn Er hat seinen Engeln befohlen über dir*
 (For he commanded his angels
 to watch over you) _2:51
 Dresdner Kreuzchor
 Gothart Stier
 ℗ 1992**

GEORGE FRIDERIC HANDEL (1685-1759)
Jephta
[11] *Tragt sie, Engel, sanft mit euch*
 (carry her, angels, gently with you) _3:39
 Peter Schreier, Tenor
 Kammerorchester Berlin
 Helmut Koch
 ℗ 1972*

JOHANN SEBASTIAN BACH (1685-1750)
Mass in B minor BWV 232
[12] *Gloria* _6:19
 Rundfunkchor Leipzig
 Neues Bachisches Collegium Musicum
 Peter Schreier
 ℗ 1984*

* VEB Deutsche Schallplatten Berlin
** Deutsche Schallplatten Berlin GmbH
 This compilation ℗ 2005 edel classics GmbH

PHOTO INDEX

RAPHAEL "THE SISTINE MADONNA",
(DETAIL) C.1513
Gemaeldegalerie Alte Meister, Dresden
photo: akg-images

ROSSO FIORENTINO (1494-1540)
"MADONNA AND SAINTS" (DETAIL)
Galleria degli Uffizi, Florenz
photo: © 1996, photo scala, florence
courtesy of the ministero beni e att. culturali

ALBRECHT DUERER (1471-1528)
"FESTIVAL OF THE ROSARY" (DETAIL)
Narodni Museum, Prague
photo: © 1990, photo scala, florence

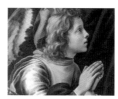

FILIPPINO LIPPI "THE MADONNA APPEARS TO
SAINT BERNARD", (DETAIL) C.1485-87
Church of Badia, Florence
photo: © 1990, photo scala, florence

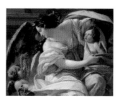

SIMON VOUET "ALLÉGORIE DE LA RICHESSE"
(ALLEGORY OF WEALTH), C.1630/35 Louvre, Paris
photo: akg-images/erich lessing

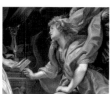

PETER PAUL RUBENS "ANNUNCIATION", (DETAIL) 1609
Kunsthistorisches Museum, Vienna
photo: akg-images/erich lessing

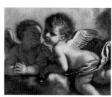

GUERCINO (1591-1666) "THE PATRON SAINTS OF THE
CITY OF MODENA" (DETAIL) Louvre, Paris
photo: © 1990, photo scala, florence

ANTON RAPHAEL MENGS "CUPID SHARPENING HIS
ARROW", AFTER 1753 Gemaeldegalerie Alte Meister,
Dresden, photo: akg-images
RIGHT: GUIDO RENI "THE ABDUCTION OF HELEN",
1631 (DETAIL) • Louvre, Paris
photo: louvre/bridgeman giraudon

TITIAN "THE WORSHIP OF VENUS", 1519 (DETAIL)
Prado, Madrid
photo: prado, madrid/bridgeman giraudon

ANNIBALE CARRACCI (1560-1609)
"A CHERUB CARRYING FLOWERS"
Musée Conde, Chantilly,
photo: musée conde, chantilly/bridgeman giraudon

PETER PAUL RUBENS "CHRIST AND ST.JOHN (BOY)",
C.1615/20 (FRUIT BY FRANS SNYDERS)
Kunsthistorisches Museum, Vienna
photo: akg-images/erich lessing

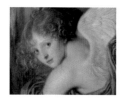

JEAN-BAPTISTE GREUZE "HEAD OF CUPID", 1786
State Hermitage, St Petersburg
photo: akg-images

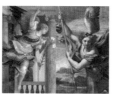

PAOLO VERONESE, WORKSHOP "THE ANNUNCIATION OF
MARY", 1560 (DETAIL) From the Scuola dei Mercanti in
Venice, Galleria dell'Accademia, Venice,
akg-images/cameraphoto
RAPHAEL (1483-1520) "SAINT MICHAEL DEFEATS SATAN"
(DETAIL) Louvre, Paris
photo: © 1990, photo scala, florence

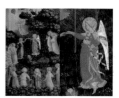

FRA ANGELICO "THE LAST JUDGEMENT", C.1431
DETAIL: THE DANCE OF THE BEATIFIED
Museo di San Marco, Florence
photo: akg-images/erich lessing

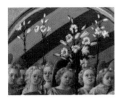

FRA FILIPPO LIPPI "CROWNING OF MARIA", 1441
DETAIL: "GROUP OF ANGELS WITH LILIES"
Galleria degli Uffizi, Florence
photo: akg-images/rabatti • domingie

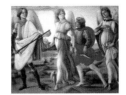

FILIPPO LIPPI (1457-1504) "THE THREE ARCHANGELS
AND TOBIAS" Galleria Sabauda, Turin
photo: © 1992, photo scala, florence
courtesy of the ministero beni e att. culturali

BENOZZO GOZZOLI "ADORATION OF THE CHILD",
1459/61 (DETAIL) Palazzo Medici-Riccardi, Florence
photo: akg-images/rabatti • domingie

HANS MEMLING
"FIVE ANGELS MAKING MUSIC", C.1470
Konklijk Museum voor Schoone Kunsten, Antwerp
photo: bpk/joseph martin

ROSSO FIORENTINO "PUTTO PLAYING LUTE", 1522
(DETAIL) Galleria degli Uffizi, Florence
photo: akg-images/stefan diller

SIMONE MARTINI (IN COLLABORATION WITH
LIPPO MEMMI) "ANNUNCIATION TO MARY", 1333
DETAIL: ANGEL OF THE ANNUNCIATION
Galleria degli Uffizi, Florence
photo: akg-images/erich lessing

ROGIER VAN DER WEYDEN "THE LAST JUDGEMENT",
C.1449 (DETAIL) Hôtel-Dieu, Beaune
photo: akg-images

JACOBELLO DEL FIORE "JUSTITIA WITH THE ARCHANGELS
MICHAEL AND GABRIEL" (JUSTITIA TRIPTYCH), 1421
DETAILS: MICHAEL (LEFT) AND GABRIEL (RIGHT)
From the Magistrato del Proprio at the Doge's Palace
Galleria dell'Accademia, Venice
photo: akg-images/cameraphoto

RAPHAEL (1483-1520) "DISPUTA (DISPUTATION
OVER THE BLESSED SACRAMENT)" (DETAIL)
Stanza della Segnatura, Vatican
photo: © 1990, photo scala, florence

RAPHAEL (1483-1520) "DISPUTA (DISPUTATION
OVER THE BLESSED SACRAMENT)" (DETAIL)
Stanza della Segnatura, Vatican
photo: © 1990, photo scala, florence

PARMIGIANINO "CUPID CARVING BOW", C.1531-34
(DETAIL) Kunsthistorisches Museum, Vienna
photo: akg-images/erich lessing

FRA ANGELICO "THE ANNUNCIATION", C.1450
DETAIL: ANGEL OF ANNUNCIATION
S.Marco Cloister, Florence
photo: akg-images/erich lessing

FRA ANGELICO "ANNUNCIATORY ANGEL", 1450-55
© The Detroit Institute of Arts, USA,
Bequest of Eleanor Clay Ford/Bridgeman Giraudon
FRA ANGELICO "CORONATION OF THE VIRGIN MARY
WITH SAINTS AND ANGELS", C.1434/35
DETAIL: RIGHT GROUP OF SAINTS AND ANGELS PLAYING
MUSICAL INSTRUMENTS Galleria degli Uffizi, Florence
Photo: akg-images/rabatti • domingie

FRA ANGELICO "ANGEL MAKING MUSIC" (LEFT)
photo: akg berlin/orsi battaglini
AND "ANGEL BEATING A DRUM" (RIGHT), 1433
DETAILS FROM THE LINAIUOLI TRIPTYCH
Museo di San Marco, Florence
photo: museo di san marco, florence/bridgeman
giraudon

SANDRO BOTTICELLI "THE BIRTH OF CHRIST",
C.1500 (DETAIL) National Gallery, London
photo: akg-images

SANDRO BOTTICELLI "THE ANNUNCIATION", 1489/90,
(DETAIL): ANGEL OF ANNUNCIATION Galleria degli Uffizi,
Florence photo: akg-images/rabatti • domingie
PHILIPPE DE CHAMPAIGNE (1602-74) "THE ANNUNCIA-
TION" (DETAIL), © Wallace Collection, London
photo: © wallace collection, london/bridgeman giraudon

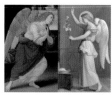

LORENZO DI CREDI "ANNUNCIATION", C.1480 (DETAIL)
Galleria degli Uffizi, Florence
photo: akg-images/rabatti • domingie
AUGUSTE PICHON "THE ANNUNCIATION", 1859 (DETAIL)
Basilique Notre-Dame, Clery-Saint-Andre,
photo: bridgeman giraudon

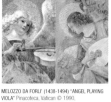

MELOZZO DA FORLI' (1438-1494) "ANGEL PLAYING
VIOLA" Pinacoteca, Vatican © 1990,
photo scala, florence
MELOZZO DA FORLI' (1438-1494) "ANGEL MUSICIAN"
Vatican Museums and Galleries, Vatican City
photo: bridgeman giraudon

BERNARDINO DI MARIOTTO DELLO STAGNO
(C.1478–1566) "RESURRECTION OF CHRIST"
DETAILS: ANGELS Galleria Franchetti, Venice
photo: akg-images/cameraphoto

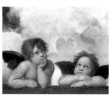

RAPHAEL "THE SISTINE MADONNA", C.1513
DETAIL: ANGELS, Gemaeldegalerie Alte Meister, Dresden
photo: akg-images

RAPHAEL "TRIUMPH OF GALATEA", 1512/13
(DETAIL) Villa Farnesina, Rome
photo: akg-images

FRANCOIS BOUCHER "CUPID'S TARGET" FROM
"LES AMOURS DES DIEUX", 1758 (DETAILS)
Louvre, Paris
photo: louvre, paris/bridgeman giraudon

TITIAN - AVEROLDI POLYPTYCH, 1520-1522
DETAIL: ARCHANGEL GABRIEL
Santi Nazzaro e Celso, Brescia
photo: © 1993, photo scala, florence

PHILIPPE DE CHAMPAIGNE "THE ANNUNCIATION"
1644 (DETAIL)
Ferens Art Gallery • City Museums/Art Galleries, Hull
photo: ferens art gallery • city museums/art galleries,
hull/bridgeman giraudon